WOULD YOU TREAD
ON A QUADRUPED?

for A to Z

A.B.

for Joseph Edmund
b. 24. 9. 1991
N.C.

POEMS BY ANTHONY BARNETT

WOULD YOU TREAD ON A QUADRUPED?

PAINTINGS BY NATALIE COHEN

An Animal Alphabet of Questionable Rhymes

ABCD

ALLARDYCE, BARNETT, PUBLISHERS
CHILDREN'S DIVISION

First published in 1992 by
Allardyce, Barnett, Publishers, Children's Division
14 Mount Street, Lewes, East Sussex BN7 1HL, UK
1 3 5 7 9 8 6 4 2

ISBN 0 907954 17 0
A CIP record for this book is available from the British Library

A antelope B bear C chimpanzee
D dove E emu F flying fish G giraffe
H hawk i I J jackdaw K kangaroo
L llama M moose N newt O owl P panda
Q quail R rabbit S scallop T turtle
U unicorn V viper W whale
x X Y yeti Z zebra

Would you elope
With an antelope?

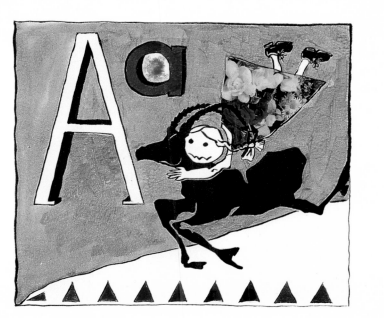

Can you repair
A very old bear?

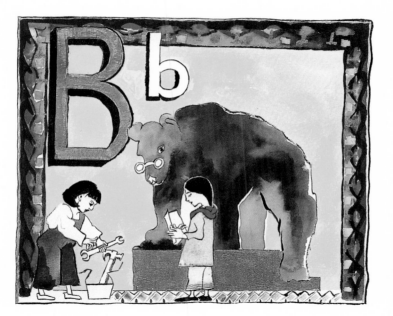

Are you as free
As a chimpanzee?

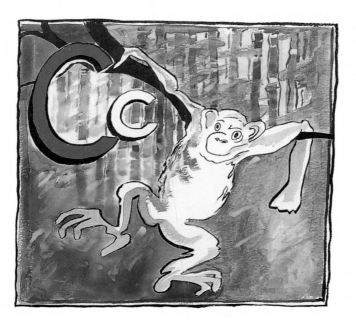

Have you fallen in love
Like a dove?

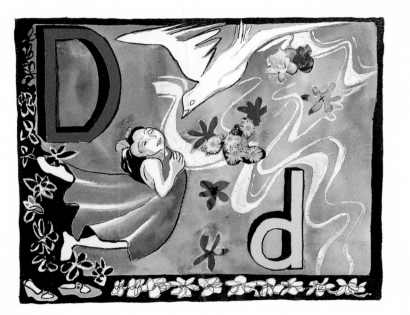

Are you you
Or an emu?

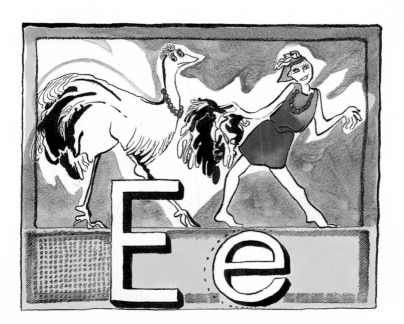

Is it swish
To be a flying fish?

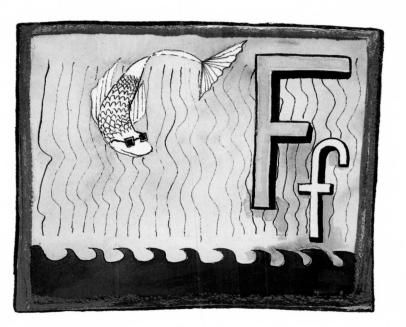

Can you choreograph
A giraffe?

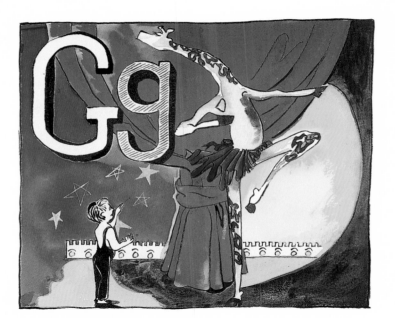

Would you squawk
At the sight of a hawk?

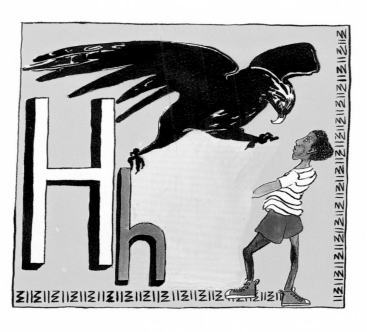

Have you an eye
For an I?

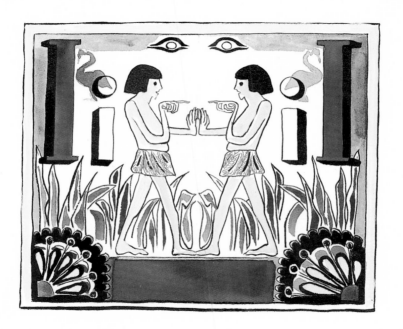

What's in store
For a jackdaw?

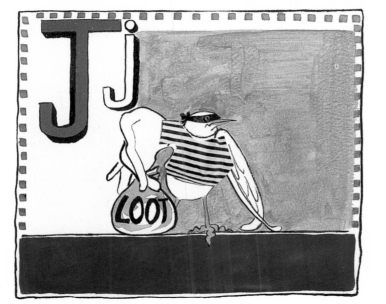

Does the didgeridoo
Delight the kangaroo?

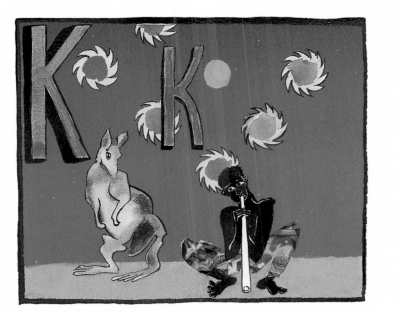

Do you know a farmer
With a llama?

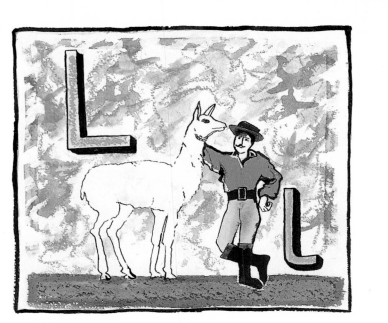

Would you say vamoose
To an approaching moose?

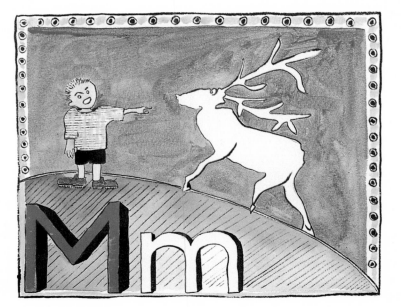

Are you astute
As a newt?

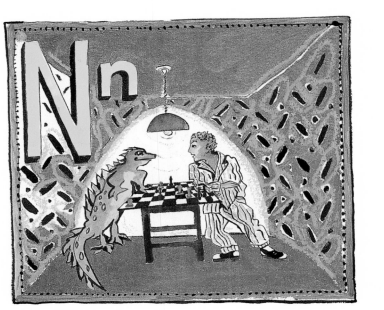

Who can prowl
Under the eye of an owl?

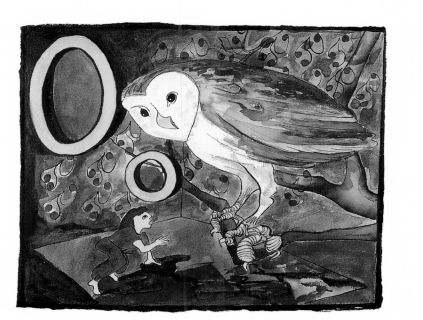

Would you pander
To a giant panda?

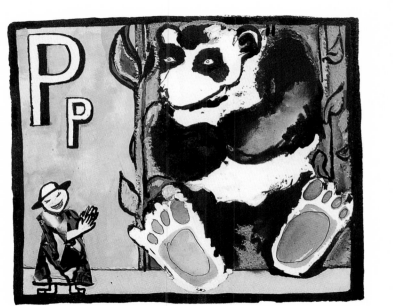

Can you put a tail
On a quail?

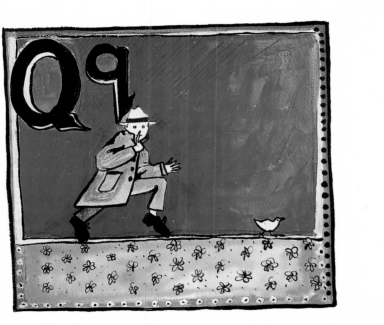

What's the habit
Of a rabbit?

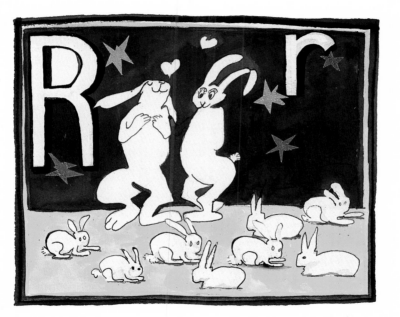

Would you wallop
A scallop?

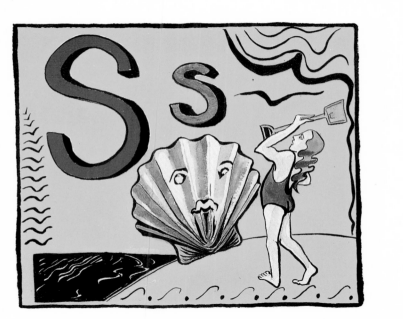

How quickly could you hurtle
Past a turtle?

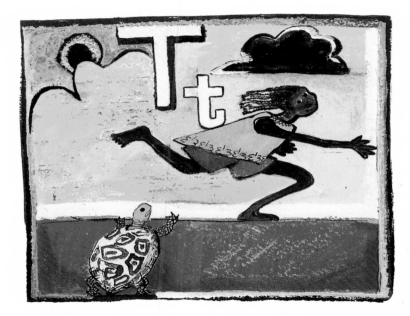

Do you scorn
The unicorn?

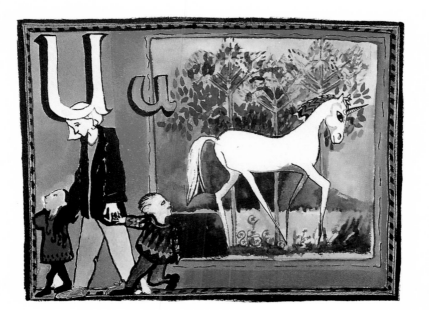

Have you heard a piper
Charming a viper?

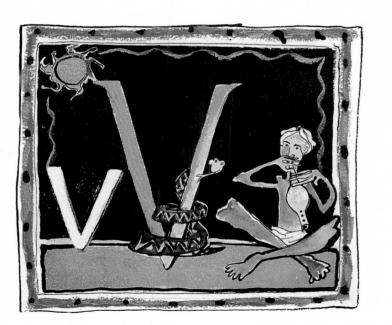

Can you fail
To spot a blue whale?

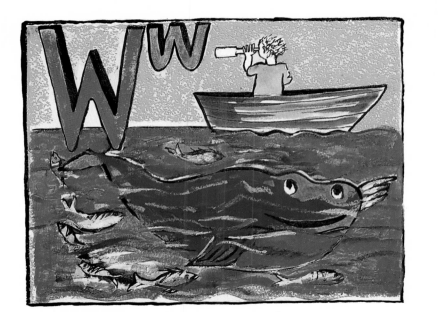

What's the sex
Of an X?

chromosome, that's Y!

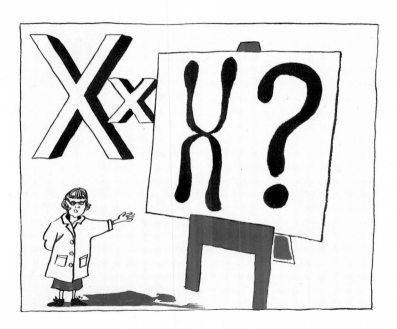

Have you met
A yeti yet?

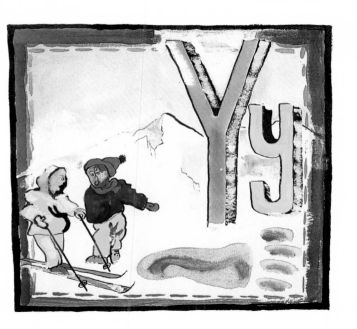

What in a zoo
Would a zebra do?

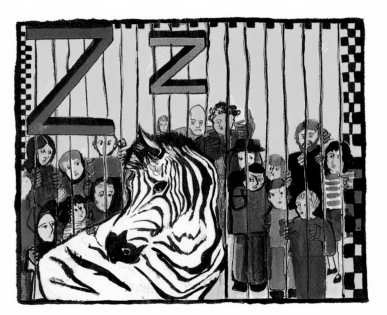

Anthony Barnett has published many books of poetry most of which are collected in *The Resting Bell*.
He has worked as a musician and written about music.

Natalie Cohen trained in fine art at the University of Newcastle and the Royal Academy Schools.
She lives in London where she exhibits regularly.

Designed by Anthony Barnett
Photographed by Joss Reiver Bany, London
Typeset by W. E. Baxter Ltd, Lewes
Printed by Laceys (Printers) Ltd, Hove